JOHANNES ITTEN

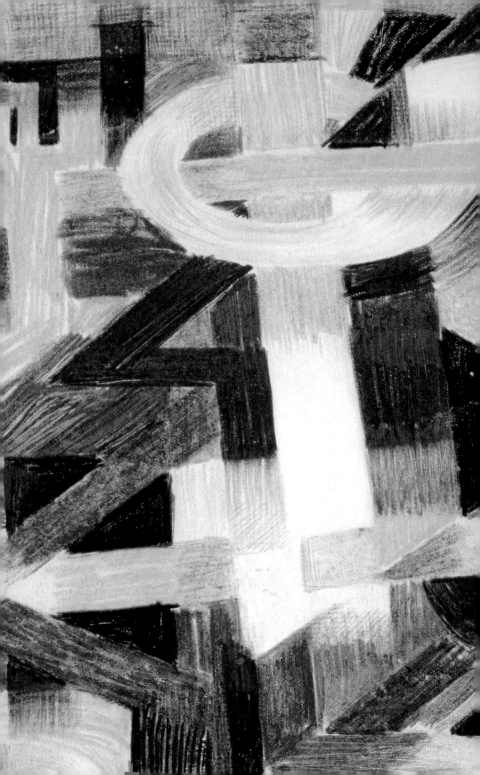

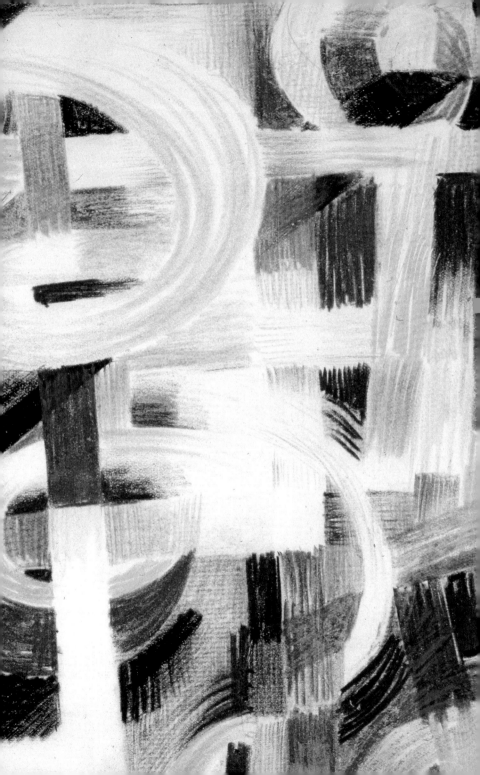

JOHANNES
ITTEN

Christoph Wagner

HIRMER

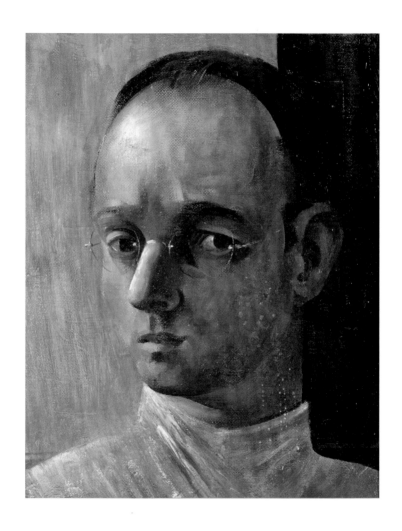

JOHANNES ITTEN
Self-Portrait, 1928, Oil and tempera,
40 × 39 cm, Private collection

CONTENTS

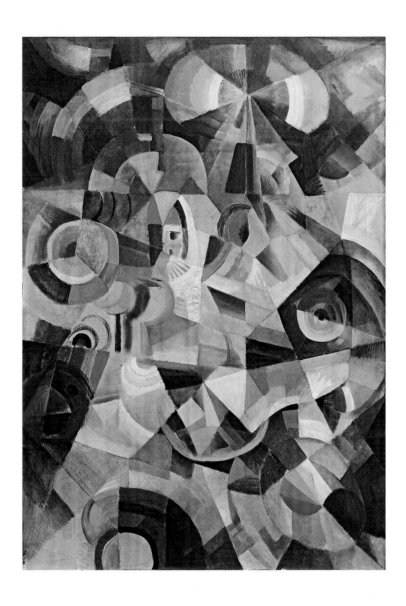

1　*Rural Gaiety*, 1917, Oil on canvas, 142.2 × 102 cm,
Kunstmuseum Bern (on loan from a private collection)

"EVERYONE HAS ARTISTIC TALENT." JOHANNES ITTEN AND ART

Christoph Wagner

Half a century before Joseph Beuys became world-famous with his aesthetic imperative "Everyone is an artist", Johannes Itten attracted attention by stating "Everyone has artistic talent" in the *Berliner Tageblatt* in 1928 and in the magazine *Die Form* in 1930. And just like Beuys many years later, Itten was also willing to let any young person participate in the classes of his art school in Berlin, because he believed there was a "being that was to be nurtured and that was capable of development" in every individual. "Every learner is an educational problem in his own right."[1] Itten tried to awaken this artistic potential for development in young students and artists, but also in ordinary people in general, and children. As a result all new students at the Bauhaus in Weimar had to complete his famous preparatory course, the "Vorkurs", which was tailored to educational reform.

Johannes Itten's life was rich in stages and experiences. After spending his youth in the Bernese Oberland and in Thun he was shaped by the artistic impressions created by Adolf Hölzel in Stuttgart from 1913 onwards, and then, from 1916 by his experience of the bright, sophisticated city culture of Vienna. In 1919 he transitioned to the experimental artist group of the Bauhaus in Weimar and in 1923 to the esoteric life of the Mazdaznan

community in the rural setting of Herrliberg. In 1926 he achieved a new beginning in the bustling Berlin of the 1920s, where he set up a privately run art school, the Itten-Kunstschule, before also starting to teach textile designers in Krefeld a short while later. It was almost as if Itten put the principles of his artistic contrast teachings into practice in his own life! All these activities were quashed under the National Socialists, and in autumn 1938 Itten found his way back to Switzerland via a stint in Amsterdam. He arrived in Zurich where he developed his ideas initially at the Kunstgewerbeschule and from 1949 at the Kunstgewerbemuseum and then, from 1943 onwards also at the Textilfachschule and at the Rietberg museum of non-European art. Itten became world-famous as a colour theoretician with the publication of *Die Kunst der Farbe (The Art of Colour)* in 1961, a work that was to be translated into many different languages.

BEGINNINGS AND EARLY PERIOD

Johannes Itten's childhood and youth were tough and were overshadowed by the death of his father in 1892 as well as by a stepfather who was perceived by the young Johannes to be "merciless". Itten characterised these years, which he initially spent in the country and then, from 1898, in the town of Thun with his aunt and uncle in order to receive an education, as "dreary", "joyless" and "grey". As a half-orphan it was incumbent upon him to start making a living as soon as possible. Accordingly, and since he was a talented but penniless young man, he followed in the tradition of his deceased father and embarked on the path of becoming a teacher. He underwent training in Switzerland in several stages between 1904 and 1912. However, the existential experience of being deprived of any form of familiar setting, intellectual or material, may have been a decisive driving force which caused him to search for his own intellectual home from a relatively young age, and in an uncompromising manner too. Itten's indelible experiences of nature were surely also part of the fundamental reality of his youth. It is not surprising that his œuvre began with depictions of nature and landscapes.

Between 1909 and 1910 Itten enrolled in the École des Beaux-Arts in Geneva: academic studies of the head, hands and body, which he produced in the classes of Louis Dunki and James Vibert, remained no more than an

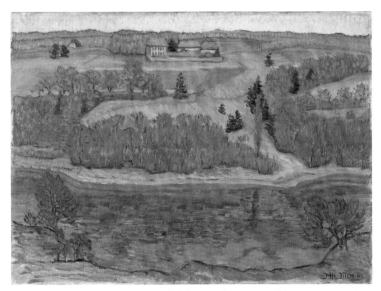

2 *Early Spring at the Rhone*, 1911, Oil on canvas, 50 × 69.8 cm,
Kunstmuseum Bern, Stiftung Emil Bretschger

episode in Itten's œuvre, even though he depicted himself next to a bust he
had made in a portrait photograph dating back to this period. By the end
of 1909 Itten had decided, much to James Vibert's regret, that he would
turn his back on the academy prematurely in order to complete a scientific
and mathematical degree at the University of Bern, leading to secondary
school teaching qualifications by 1912. In December 1911 Itten made his
public debut as an artist in the Christmas exhibition of the Kunstmuseum
in Bern, where he displayed his oil painting *Early Spring at the Rhone* (2).
After a second intermezzo at the École des Beaux-Arts in Geneva during
the winter semester of 1912/13 he was lured to the academy in Stuttgart by
Adolf Hölzel's art in October 1913.

ITTEN'S STUTTGART PERIOD

Itten walked from Basel across the Feldberg to Stuttgart, firmly deter-
mined that he would become a painter. Since the admission committee
initially refused to let him participate in Hölzel's classes at the academy, he

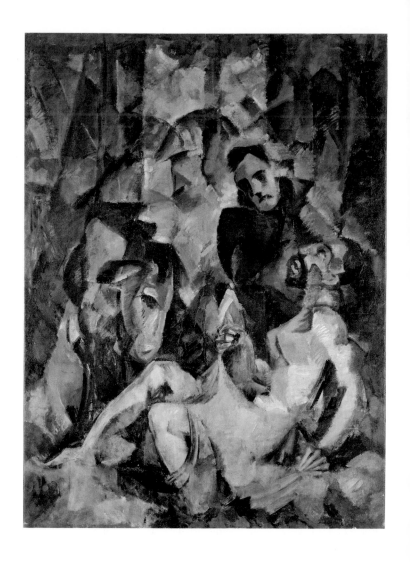

3 *The Good Samaritan*, 1915, Oil on canvas, 200 × 151 cm,
Kunstmuseum Luzern

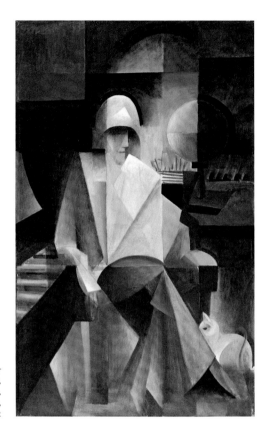

4 *The Bach-Singer (Helge Lindberg)*, 1916, Oil on canvas, 160 × 101.5 cm, Kunstmuseum Stuttgart

had no other option but to take private lessons from Hölzel's student Ida Kerkovius in order to learn about Hölzel's teachings on art. Among Hölzel's students at the time he was one who demonstrated a degree of maturity after having completed his teacher training, but he had thus far barely distinguished himself as an artist, having just a meagre œuvre consisting of portraits, landscapes and academic figure studies. In Stuttgart he produced paintings in which he confronted Hölzel's geometric prismatism in the creation of forms within the context of his intensive study of Cézanne and Cubism. On 27 July 1914 he was taken by surprise by the outbreak of World War I: "'There's a war. Didn't you know?' How was I supposed to know – I had read barely any newspapers for the whole winter [...]. I immediately packed my bags, said goodbye to Hölzel and

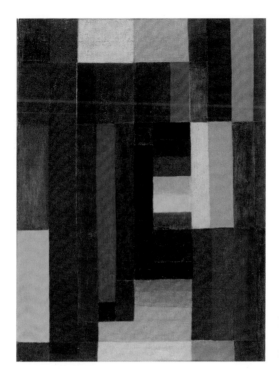

5 *Horizontal–Vertical*, 1915,
Oil on canvas, 73.7 × 56 cm,
Kunstmuseum Bern,
Anne-Marie und
Victor Loeb-Stiftung

Kerkovius, saw Schlemmer and Stenner, who were both dismayed by the military developments."[2]

Itten returned to Stuttgart from Switzerland in early November 1914, after Hölzel offered him one of the sought-after master-student studios in the artists' residence. In his main work of 1915, *The Good Samaritan* (3), he reflects on the events of the First World War not only by taking inspiration from Hölzel's depictions of the Lamentation, but also from the paintings of Hermann Stenner, who had recently been killed in action.

In spring 1916 Itten worked on the painting *The Bach-Singer (Helge Lindberg)* (4), in which he – starting with the figurative style – embarked into a geometric, abstract formal language. His departure from figurative art can also be traced in his diary entries: "Figurative or abstract: […] A painter has lines, forms, light & dark and colours as expressive tools. His artistic work is defined by how he deploys these, coupled with good proportions, formal relationships and distributions of colour contrasts to create a vital,

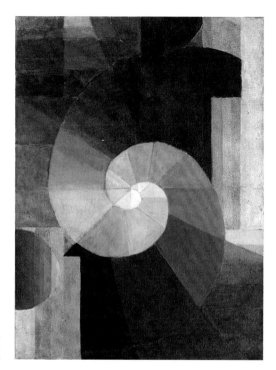

6 *The Encounter*, 1916,
Oil on canvas, 105 × 80 cm,
Kunsthaus Zürich

expressive, harmonious whole."³ Following Hölzel, he had initially experi-
mented with "combining free art forms with object forms"⁴; then, from
November 1914 onwards, he was influenced by reading Vasily Kandinsky's
exposition on art theory "On the Problem of Form" in the almanac *Der
Blaue Reiter*⁵, which led him to try and separate figural references and
abstractions. Itten implemented this shift to an abstract pictorial language
in 1915 and 1916, at first in Stuttgart and then in Vienna, in a number of
purely geometric, abstract key works such as *Horizontal–Vertical* dated 1915
(5), *The Encounter* (6) dated 1916 and *Rural Gaiety* dated 1917 (1). The
paintings are characterised by the style of a geometric abstraction in which
rectangular, circular and spiral structures are combined with paradigmatic
colour configurations. Itten appears to have tried out the fundamental
principles of the formal and colour order of his abstract pictorial vocabul-
ary in each of these paintings, as if producing examples of each. If the term
'avant-garde' referring to utopian designs of the aesthetic before the time

of their establishment was ever of use, then, with Itten's later work at the Bauhaus in mind, it is appropriate for this series of works.

In the painting *The Encounter* Itten framed a horizontal-striped structure made up of the colour scale from yellow via orange, red and green to violet and blue framed on both sides with vertically placed metallic colours – silver, gold, brass and bronze. At the centre of the picture this striped colour structure transitions dynamically into a double spiral: rhythmically structured light-and-dark gradations along the black and white scale interlock with the different colours on the spectrum in order to culminate in a whitish grey and the lightest pastel yellow at the centre of the spiral. The totality of the colours seems to be coupled with the axiomatic claim of a colour model in this painting, as if Itten wanted to place himself within the long tradition of models of colour theory since Aristotle, d'Aguilon, Goethe, Runge and Hölzel by creating a colour order of his own. A few years later, at the Bauhaus, he would indeed publish his first theoretical colour model, the *Colour Globe in 7 Light Stages and 12 Tones (Farbenkugel in 7 Lichtstufen und 12 Tönen)* which becomes a colour star when laid out flat (see p. 70) – this was a contribution to the almanac *Utopia: Dokumente der Wirklichkeit*.

Itten's diary entries on art theory help us to gain a better understanding of the work *The Encounter*. He produced an initial design sketch on 20 May 1916 in connection with a traumatic biographical event – the suicide of his girlfriend Hildegard Wendland in Stuttgart. In the first version of the *Resurrection* painting (7) Itten produces a moving painted epitaph to this experience of death by interlacing figurative and abstract formal elements. The picture, which today only exists indirectly in the form of documentary photographs, is inscribed with the date 1 April 1916. Around seven weeks later Itten produced *The Encounter*. The explicit biographical reference that exists in the diary entry has been removed from the title: "Umarmung" ("Embrace") and "Himmelskuss der Hilde" ("Hilde's Heavenly Kiss") become the more general *The Encounter*. This connection illuminates the fact that the painting is not just to be understood as a geometric, abstract experiment in form and colour; rather, Itten sees the colour spiral as a symbolic code relating to a metaphysical background, something he soon tried to develop further with esoteric speculations.

Such an abstract translation of emotional experiences, including existential experiences of love and death, i.e. the attempt at objectifying emotional

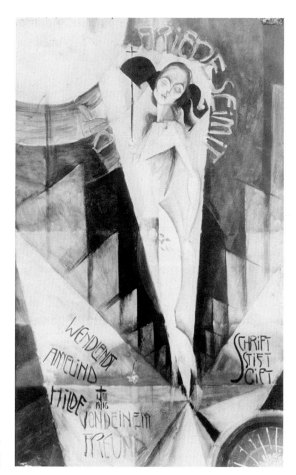

7 *Resurrection* painting, 1916, Oil on canvas, lost

experiences using the purely visual means of geometrically rationalised abstraction, is not an isolated case in Itten's work at this time. Compared to *Rural Gaiety* dated 1917, which is characterised by cheerfully revolving movements, *Composition in Blue* (8) dating from late 1918 and early 1919, is associated with a surprisingly dark background: "...I painted this picture in memory of a dear person who had died suddenly."[6] Itten is referring to the death of 22-year-old Emmy Anbelang, who had been Gustav Klimt's last lover and who, after the latter's death on 6 February 1918, had become Johannes Itten's student and lover. She fell ill with the Spanish flu in early

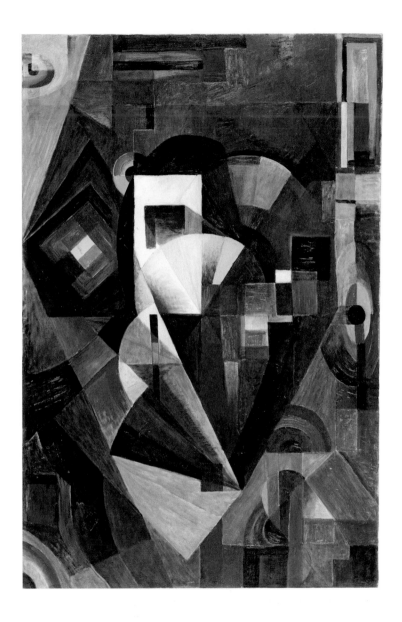

8 *Composition in Blue*, 1918, Oil on canvas, 120 × 80.5 cm,
Kunstmuseum Bern, Gottfried Keller-Stiftung

December and died soon after, on 14 December 1918. Nine months after Emmy's death Itten married her sister Hildegard. Developing the dynamism of Cubist, Futurist and Orphic pictorial ideas, he found a new form of pictorial abstraction in *Composition in Blue*. It was an abstraction he experimented with during this time along with figurative and abstract drawings and relief images as well.

ITTEN'S PRIVATE ART SCHOOL IN VIENNA

Itten, who was aged 27 at the time, had moved to Vienna in October 1916; once there he had established his Private Kunstschule at Nussdorferstrasse 26–28. It had been the socially well-connected student Agathe Mark(-Kornfeld) from Stuttgart who encouraged him to move to Vienna and then continued to support him financially too. It was also she who paved the way for Itten into Viennese society and into Vienna's artistic avant-garde circles from autumn 1916. This is where he soon met artists, architects, composers, poets, philosophers, art historians and bons vivants: Carl Moll, Josef Hoffmann, Adolf Loos, Franz Werfel, Arnold Schönberg, Alban Berg, Josef Matthias Hauer, Hans Pfitzner, Rudolf Steiner, Hans Tietze and Josef Strzygowski, to name but a few.

Shortly after his arrival he also met Alma Gropius, the widow of Gustav Mahler. Her second marriage at that time was to Walter Gropius, and lasted from 1915 to 1920. As Itten's advocate she was the crucial factor in his later appointment to the Bauhaus. Itten and Walter Gropius met in late June 1918 during a summer sojourn in Alma's holiday home on the Semmering in the Viennese Alps. During a conversation about the Bauhaus, which Gropius was planning in Weimar, Alma allegedly said to Gropius: "If you want to be successful with your Bauhaus idea, then you must appoint Itten."[7] When Gropius saw paintings by Itten in Vienna for the first time, he is said to have commented: "I don't understand your pictures and your students' works but if you want to come to Weimar, I would be pleased to have you."[8]

Once he started teaching students at the Bauhaus in Weimar, Itten – it goes without saying – drew upon methods he had tested and strategically developed at his school in Vienna. They focused in particular on the students' psychological self-exploration and self-awareness, rhythmic exercises, and

studying the fundamental artistic tasks in the areas of composition, the character of forms, chiaroscuro, colour and proportions (9). As Itten's diary entries reveal, even in Vienna he had already started to experiment with the exercises for individual expressive subjects and forms in artistic design; the "rhythmic depiction of a storm" is one such example. He gave the study of the Old Masters a central place in his students' training, both in Vienna and then later in Weimar. The aesthetically effective coupling of expression and movement, as Itten demonstrates in the well-known picture of the thistle (see p. 75) and as it was published at the Bauhaus in 1921 in the almanac *Utopia: Dokumente der Wirklichkeit* (see p. 74), was another discovery he had already made during his teaching activities in Vienna. In the Viennese records from the end of 1918 and beginning of 1919, Itten wrote: "I had them draw a thistle and of course all of them traced the thistle more or less well. I proceeded to show them Dürer's Christ as the Man of Sorrows (thistle pain motif). I now demanded that the student let himself be pricked by the thistle. – He feels the painful, barbed, sharp aggressive nature of the thistle; he is to represent this as a pure movement sensation on the sheet, then he will have felt and shaped the nature of the thistle."[9] In a number of ways Itten's move from Vienna to the Bauhaus in Weimar should be viewed not as a break, but rather as a continuum.

Itten's diary entries and his library, now housed in Zurich's central library, confirm that he had taken a keen interest in theosophical and other esoteric writings ever since his time in Vienna. He tried to depict his ideas about people's colourful aura in sketches or to analyse it in the form of "magic squares" (see p. 72). Rudolf Steiner and Itten had met personally on the occasion of a lecture Steiner gave in Vienna in 1918. Itten had little to say about the encounter that was positive: "I went to a lecture by Dr Rudolf Steiner last night. He did not seem to have anything more important to do than to prove that my artistic way of working was the most consummate. [...] However, I am still sceptical about his speeches. He is quite unartistic – and so I don't quite believe he has had the experiences he says he has."[10] This clear rejection of Steiner must also be understood within the context of Itten's world view that was forming at this time, a world view that focused on the principles of the Mazdaznan teachings. This syncretist religion founded by Otoman Zar-Adusht Hanish blended Zoroastrian, Christian and Hindu-Tantric ideas, accompanied by a vegetarian diet, breathing techniques based on yogic principles and seriously cranky

9 *Ribbons (Movements)*, 1918, Coloured pencil on paper,
23 × 31 cm, Private collection

teachings on race based on Helena Blavatsky's theosophical ideas. Sources confirm that Itten's interest in the Mazdaznan religion did not begin when he was already at the Bauhaus. Rather, he had begun taking a detailed interest in this esoteric world view when he was in Vienna and was in contact with members of the international Mazdaznan temple community over many years.

The weeks that Itten spent in Sigriswil near Lake Thun in Switzerland during the late summer were among his most productive for the development of his art theory: in his diary entries of this time he sketched almost all the artistic and art-theoretical aspects that he went on to implement during his time at the Bauhaus: rhythm and harmony in music and painting, teachings on polarity and colour, form of expression, analyses of Old Masters and time-space movement as a subject.

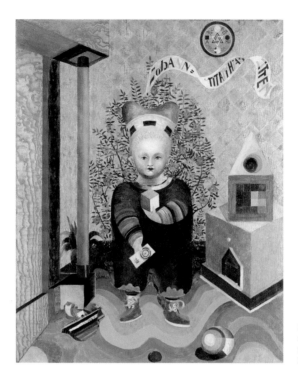

10 *Children's Portrait,*
1921, Oil on wood,
110 × 90 cm,
Kunsthaus Zürich

AT THE BAUHAUS

On 24 February 1919 Itten received a written invitation from Walter Gropius to become one of the first masters at the Bauhaus in Weimar. In late autumn he moved into his studio in the Tempelherrenhaus in the Park an der Ilm, which had been converted into a neo-Gothic temple under the architect Carl Friedrich Christian Steiner in the early nineteenth century. This was where Itten produced significant works such as *Tower of Fire (Tower of Light)* (38) and *Children's Portrait* (10), and where he made observations about art theory in his Tempelherrenhaus diary. It is a curious paradox in Johannes Itten's artistic career that during his three and a half years at the Bauhaus in Weimar, between October 1919 and March 1923, he did not produce a single painting in the geometric abstract style like those produced during his years in Stuttgart and Vienna; instead, his few pictures from this period are characterised by a return to a figurative, represen-

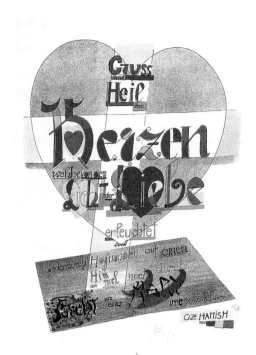

11 *Salute and Hail to the Hearts*,
Lithograph for the first Bauhaus
portfolio, 1921, 34.5 × 24.5 cm

tational style. He also produced calligraphic works shaped by his world-view: for the first Bauhaus portfolio of 1921 Itten illustrated a saying by the founder of the Mazdaznan movement O. Z. A. Hanish: "Salute and hail to the hearts"; art and esotericism merge here in programmatic manner (11). *Children's Portrait* too, which he painted in honour of his son's birth in 1921/22, can be read as a symbolic, pictorial mystery of the esoteric teachings of the New Man. It was not until three decades later, in the early 1950s when he had left the Bauhaus far behind him, that Itten abandoned a painting style dominated by figural depictions in favour of a return to abstract, geometric compositions.

Itten developed the "Vorkurs", the preparatory course, for the Bauhaus. This was a compulsory introductory semester for all students, which he gave, alternating with Georg Muche, until 1923. As "master of forms" he was present in all the workshops, except for the ceramics workshop, the bookbinding shop and the printing shop. His worldview became increas-

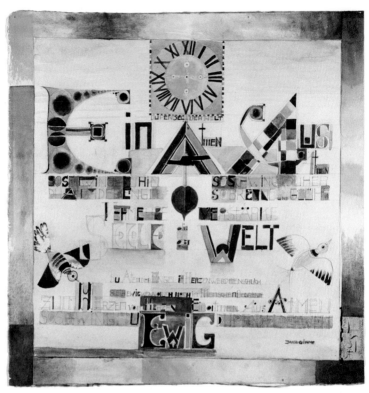

12 *Breathe in, Breathe out*, 1922, Coloured pencil and watercolour on paper, 30 × 30 cm, Private collection

ingly apparent. He started disseminating the Mazdaznan teachings among the Bauhaus students. From 1920 onwards Johannes Itten began working towards a comprehensive spiritualisation of all aspects of life (12). This was immediately apparent in the costume which he had designed himself and which he decided to wear, and in his shaven head (34). His efforts at reform even included the menu of the Bauhaus canteen, which he changed to reflect the Mazdaznan diet. After conflicts with Walter Gropius that had been smouldering for almost two years, Itten finally left the Bauhaus in March 1923 in order to join the international Mazdaznan temple community in Herrliberg on Lake Zurich.

In order to arrive at an appropriate historical understanding of Itten's esoteric views on this matter, we must remind ourselves beforehand that the term "race theory" ("Rassenlehre") has become inextricably linked to inhumanity since the National Socialist dictatorship and its racial ideology after 1933. However, Johannes Itten's views should not be read within an anti-Semitic context; rather, they should be seen within the historical context of evolutionary ideologies of theosophy and the Mazdaznan teachings. To judge these considerations, which are still highly disturbing to us today, we must keep in mind that Itten continuously and intensively studied African and Asian art from his years in Stuttgart, respecting it as a genuine artistic creation. As his library documents, he collected many publications on non-European art and studied it through his own works. Nowhere in Itten's notes do we find anti-Jewish or anti-Semitic comments. On the contrary: Itten saw Jewish culture as connected to early Christianity within a broader historical context, and as an integral component of what he saw as a venerable gnostic tradition that he investigated via the many publications that were in his library.[11] Impressive proof of this can be found in the 1909 book by the Jewish religious philosopher Martin Buber *Ekstatische Konfessionen*, which he expensively and lovingly bound in July 1920; Itten made an intensive study of its contents too.[12] In the disputes at the Bauhaus, Walter Gropius expressly classes Itten as being part of a "Jewish" faction: "The Bauhaus is full of conflict everywhere [...], Itten's students against the Teutons [...]. The thing is this: the intellectual Jewish Singer-Adler group has become utopian and has unfortunately had a significant impact on Itten too. They want to use this lever to get their hands on the entire Bauhaus. Naturally, the Aryans [sic] rebelled against that. Now I have to make the peace. [...] It's clear to me that people like Singer-Adler don't belong at the Bauhaus and must leave in time, if calm is to be restored."[13]

In recent research the difficult attempt has been undertaken in order to analyse the expansion of racial ideologies from more precise historical perspectives, distinct from the question of National Socialist racial fanaticism, so that justice may be done to the scholarly and cultural contexts of this subject, which are independent of any Nazi ideology. It is an exercise that is far from over. Werner Brill appositely emphasises that the idea of "racial hygiene", which "grew in significance after World War I, initially in

academic circles and then later also among the general public," is in "no way to be equated with the later Nazi racial ideology".[14] It was from this contemporary context that Itten took up individual aspects and ways of thinking prevalent at the time, and they influenced his ideas of an international history of "human and artistic development" when speaking of the "evolution of humankind" or of the "evolutionary development of the white, Aryan race".[15] Repulsive as this terminology and these considerations are to us today, we must also emphasise that there are no ideas of "racism [...] directed against alien races" or of "social racism [...] directed against certain groups of the population not ethnically distinct ('inferiors')" here, such as Brill often diagnoses in the racial theories of the Weimar Republic between 1919 and 1933.[16]

THE ITTEN SCHOOL IN BERLIN

Itten underwent one of the most surprising metamorphoses of his life when he moved to Berlin on 1 October 1925. It would be hard to find a greater contrast than that between his retreat to the rural, esoteric way of life in the Mazdaznan community in Herrliberg between 1923 and 1925 and his project of a privately funded art school in the metropolis of Berlin! His matter-of-fact, objective view of himself is documented in a photographic self-portrait of 1928 (39). Even though Itten continued to give Mazdaznan lectures, and the legendary breathing and physical exercises remained part of the curriculum at the Itten School, the esoteric side of the Mazdaznan teachings now took a back seat. With his courses, which he initially gave in different locations, Itten struck a chord with the zeitgeist to such an extent that he, together with the builder Wilhelm Peters, was able to implement plans for a new building for the school at Konstanzer Strasse 14 as early as 1928. Intensive public relations work helped spread the word about the Itten School. At times more than 100 students came from all over, including a not insignificant number who later emerged as artists in their own right and continued the traditions of the school in the avant-garde movements of the post-war era. Not only did Itten employ teachers who had graduated from the Bauhaus – for example Georg Muche, Lucia Moholy, Gyula Pap and Max Bronstein. From 1932 he also hired teachers of Japanese ink-wash painting, including Yumeji Takehisa (41, 13). In next to no time

13　*The Mountain*, 1929, Oil on canvas, 120 × 100 cm,
Private collection

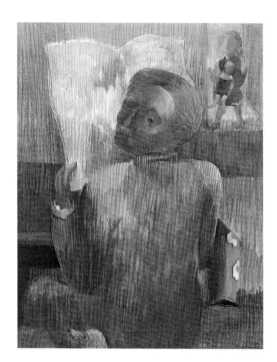

14 *The Reader*, 1931,
Coloured pencil and
watercolour on paper,
34.5 × 24 cm,
Private collection

the Itten School had become a serious competitor to the Bauhaus, which had moved to Dessau in 1925. Ironically, once in Berlin, Itten also returned to the close connection between artistic training and job-related orientation, even though this was what had caused the rift with Gropius at the Bauhaus. In addition to upcoming artists he also wanted to train architects, photographers, educators and graphic designers, and, starting in 1932, textile designers too.

KREFELD

Flanked by the publication of his 1930 diary and a full schedule of lectures, teaching and exhibitions, Itten achieved the high point of his career in Germany in January 1932 when he was appointed to the *Höhere Preussische Fachschule für textile Flächenkunst* ('Prussian Academy of Textile Art') in Krefeld.

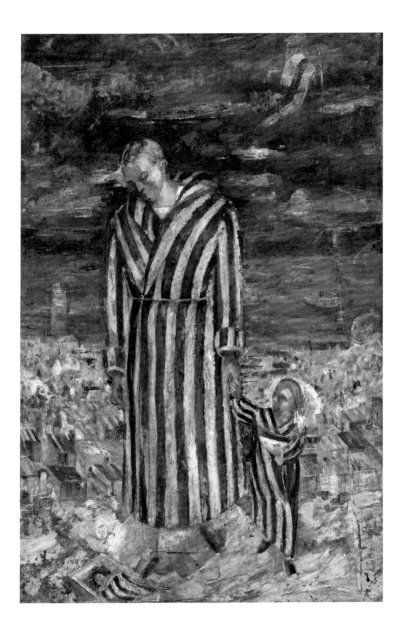

15 *The Man by the Sea*, 1930, Oil on canvas, 120 × 80 cm,
Private collection

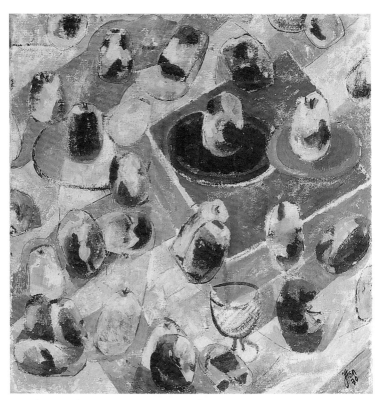

16 *Apples*, 1930, Oil on canvas, 70 × 70 cm, Private collection

In the early 1930s Itten produced several figurative works (14, 15) in which he explored the relationship between figure and space in a new way. In other works, such as *Apples* dating from 1930 (16), with their planar compositions open to the sides, it becomes clear that Itten's perspective of the visible changed as a result of the experiments of his photography class in Berlin. During these years Itten's interest in exploring colour grew markedly, and this was increasingly represented in his work, for example in the watercolour *Man in the Garden* (17). Abstraction made a first comeback in 1934 in the austerely planimetric colour-field composition, in which the figural naturally remains present.

Itten's comprehensive investigation of questions surrounding textile ornamentation in Krefeld had an effect on his paintings from around 1935. The

modes of representation, like the fabric patterns, became more abstract. One of the most original ways of obtaining textile ornaments in Itten's lessons in Krefeld lay in the translation of photographic figural motifs into abstract forms. From now on we can see similar strategies in the pictorial abstraction in Itten's paintings. A key work from this period, *Birds by the Sea* (18), features figuration and abstraction closely intertwined.

Itten created the most intimate and at the same time most monumental fusion of textile ornamentation and pictorial painting in the early summer of 1938, when he produced a transparent ceiling cover for the stairwell of the Stedelijk Museum in Amsterdam (19). The *Velum*, which no longer survives, measured 18 by 9.5 metres and adorned the atrium during the survey exhibition *100 Years of French Art*. Itten was awarded the commission for this work on 29 April 1938 by the second director of the

17 *Man in the Garden*, 1934, Watercolour on paper, 17 × 19 cm, Private collection

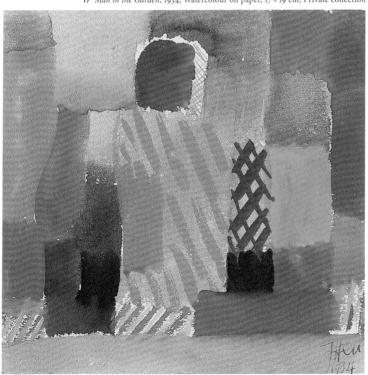

18 *Birds by the Sea*, 1935, Oil on canvas, 176 × 115 cm,
The Würth Collection, Künzelsau

19 Complete composition
of the *Velum*, 1938, Pencil
and gouache on paper,
192 × 103 cm, Private collection

museum Willem Sandberg, whom he had known via Mazdaznan contacts
since 1925. It develops the fundamental hieroglyphic vocabulary of man
within the subject of the creation: accompanied by motifs of nature,
human figures dance in an abstract rhythm against a diaphanous back-
ground. Itten had spent two decades studying intensively the encyclo-
paedic diversity of glyphs from different cultural spheres, periods, and
intellectual contexts.

After his spectacular rise, Itten gradually experienced the end of all of his professional artistic opportunities in Germany under increasing Nazi repression. The Itten School in Berlin was closed down at Easter 1934, and on 19 July 1937 the *Degenerate Art* exhibition, designed to ridicule and vilify exhibits, opened in Munich. Itten was represented with two works. In the wake of this and as a result of increasing Nazi pressure, many of his works were removed from public collections.[17]

It was not a coincidence that the almanac *Utopia* (see page 74) in the Schlossmuseum in Weimar, in whose design Itten had been keenly involved, was also a victim of the Nazi "purging" of German art collections. The confiscation inventory of the "Degenerate Art" research centre lists 33 of Johannes Itten's works.

In addition to the calligraphic design of pages in *Analysen Alter Meister*, which Itten created for the *Utopia* almanac, his large-format prints *Salute and Hail to the Hearts...* (11) and *The House of the White Man* (20) also attracted the attention of the Nazi art-persecution machine. Starting with the *Degenerate Art* exhibition in Munich's Hofgarten arcades, by 1941 Itten's works had been displayed at no less than thirteen exhibition venues. Itten was surely not being naïve when he demanded in a letter (only recently discovered) dated 26 February 1938 and addressed to those responsible for the visual arts in the Reich Chamber of Culture "that you remove all works and comments pertaining to me from the 'Degenerate Art' exhibition".[18] He enclosed with this letter the "membership book" (number M 8995) that was obligatory for all artists working publicly in Nazi Germany, thereby making it clear that he was going to leave Germany.

In letters dated 14 November 1937 and 4 January 1938, Itten asked Gropius for support for his plan of emigrating to the United States.[19] On 26 November 1937 he was dismissed from the directorship of the college in Krefeld; the institution itself was closed on 31 March 1938. Rotzler notes that Itten experienced "repeated house searches" during this time.[20] On 3 March 1938 Itten wrote to Oskar Schlemmer in dismayed tones: "Everything has changed for me today. [...] I too am faced with ruin. [...] I'll still be in Amsterdam in March [...] but I'm hoping to move to the United States."[21] Indeed, he travelled to Amsterdam that same month and, starting on 30 March, made a living with lectures and courses for painters and archi-

20 *The House of the White Man*, 1921, Lithograph, 35 × 28 cm

tects and with the commission for the *Velum*. After he had completed the *Velum* Johannes Itten temporarily withdrew to Düsseldorf on 25 June 1935 in order to make his way from there to Switzerland and Zurich, which became the centre of his life and work from December 1938.

It was in this context that Itten produced the painting *Tellenwacht* (21), featuring William Tell, which at 2.25 × 1.45 m was the second-largest picture he had ever painted. From a stylistic perspective the painting holds a special position within Itten's œuvre in several regards: the martial presentation of a monumental heroic figure makes use of motifs taken from figurative hero portraiture and history painting as well as Hodler's iconic depiction of Tell. Itten's *Tellenwacht* painting is his personal re-enactment of the legendary founding oath of the Swiss Confederacy in the patriotic sense of a Swiss *national spiritual defence*. His picture is a returnee's homage to Switzerland.

Diametrically opposed as *Tellenwacht* and *Velum* are on a stylistic level, their political intentions are such that they can be read as programmatic in the sense of regaining artistic freedom and of personal resistance

against the "impossible situation" in Nazi Germany – as Itten described it in his farewell speech in Krefeld in 1937[22]. In both works Itten endeavours to connect to archaic archetypes of the cultural visual memory. In *Velum* he does so using the hieroglyphically abstract language of reduced pictograms; in *Tellenwacht*, via the narrative revival of a Swiss national legend.

ZURICH

Itten was able to continue his artistic life's work in several different ways following his permanent return to Switzerland, where he was appointed head of the Kunstgewerbeschule and Kunstgewerbemuseum in Zurich on 1 December 1938. He assumed responsibility for the running of the textile college between 1943 and 1960, and from 1949 started to build up the Museum Rietberg, which opened on 24 May 1952. At the same time he provided an example of a counterdesign to the barbarism of Nazi Germany by continuing the Bauhaus tradition of elementary design theory at the Kunstgewerbeschule on the one hand, and by building a museum for non-European art on the other. The adventurous story of the retrieval of 25 large Chinese sculptures from the Von der Heydt collection in the Ostasiatisches Museum in East Berlin in 1951 to the Museum Rietberg alone demonstrates the personal commitment invested by Itten in this area too. He handed over some Lenin memorabilia (a tea glass, a tea strainer and two butter knives with horn handles) in exchange for the Chinese works.

ITTEN'S COLOUR COSMOS

Johannes Itten produced one of the most significant theories of colour of the twentieth century. Many years before Paul Klee focused on the classification of colours at the Bauhaus, Itten developed a comprehensive colour theory based on Adolf Hölzel and Philipp Otto Runge's colour sphere. Through letters and diary entries we can trace his intense, life-long confrontation with colour: the *Colour Sphere* that Itten published in 1921 (fig. p. 70) is a key work in this regard. His *Tower of Fire* from 1919/20 (38)

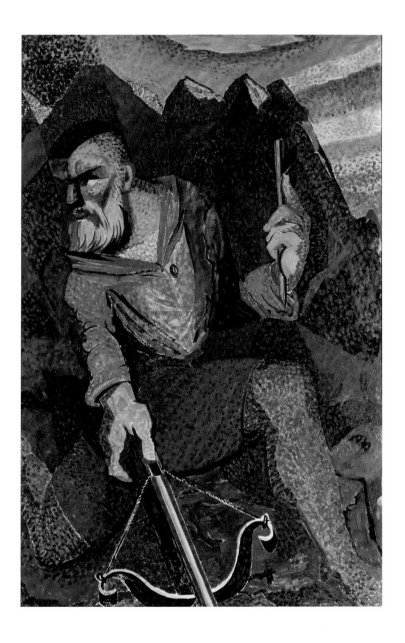

21 *Tellenwacht*, 1940, Oil on hardboard, 225 × 145 cm,
Kunstmuseum Bern

demonstrates particularly clearly just how much Itten tried during his time at the Bauhaus to combine the classification of colours with astrological or esoteric notions of a cosmic model of the world.

It was Adolf Hölzel who initiated Itten into the field of colour theory during his time as a student in Stuttgart; he introduced him to the essential foundations, such as his eight or twelve-part colour spheres, mirroring musical classification, and his teachings on colour contrast and harmony. As early as 1915 Itten sketched a colour sphere in which he also explored relationships between the classifications of colour and the classifications of the musical soundscape (22, 23). During his Bauhaus years Itten outlined the project of a universal theory of colour, in which he sought to "construct a colourful sphere and secondly a model of man with the sound and colour spheres as its localisation".[23] In his diaries we find the traces of such a search for a universal classification of colours as well as attempts at ordering colours based on astrological aspects, the four-temperament theory, the four elements, alchemical or mineralogical criteria or analogies to music. Like Hölzel – albeit with modifications – Itten lists seven contrasts: "colour-in-itself contrast", "light-dark contrast", "cold-warm contrast", "complementary contrast", "simultaneous contrast", "quality contrast", and "quantity contrast".[24] Itten's colour theory has occasionally and unfairly been viewed as a mere variation on Hölzel's. If we look at the evolution of Itten's colour theory, we can see that his ideas differed increasingly from Hölzel's in fundamental points, especially during his Vienna and Weimar years.

Hölzel had designed his theory of colour contrasts, by analogy to Goethe's dictum, as the "basso continuo of painting", thereby limiting it to the two-dimensional visual arts. Itten on the other hand tried to expand his colour theory into a cosmology on a symbolic level. An example of this can be seen in Itten's reflection on colour theory in connection with the design of his *Tower of Fire*, which rises upward in twelve colour steps. This architectural, sculptural monument is Itten's attempt to relate the cosmos and the colour cosmos to each other in a symbolic way.

In connection with this re-orientation Itten prefers the concept of the colour sphere, which he adopted following Philipp Otto Runge, over the planimetric diagram of the colour circle. It is important to keep in mind in this context that Itten viewed his colour star as a two-dimensional projection of the "colour-sphere".

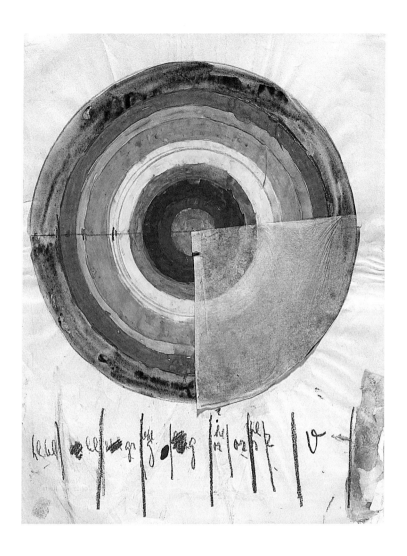

22 *Colour Circle*, 1915, Watercolour, pencil and collage on paper,
27.5 × 21.3 cm, Private collection

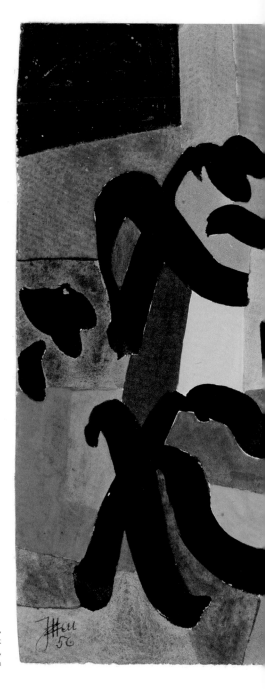

23 *Evening Music*, 1956,
Tempera and Indian ink
on paper, 34.5 × 39 cm,
Private collection

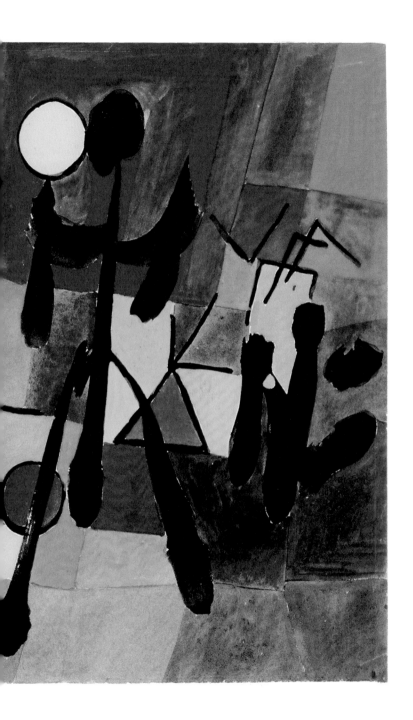

In the context of an expansion of his colour theory into a comprehensive worldview, Itten tried incorporating theosophical, astrological and other historical systematisations of colour and symbolic attempts at ordering things, which would have been inconceivable for Hölzel. Hölzel was aware of this fundamental difference between his theory and the artistic attitudes of his students: "My students have jumped right into the metaphysical with their opinions." He modestly continued: "I myself am not there yet. I have not yet sufficiently explored the limits of earthly possibilities in art."[25] Itten was undoubtedly one of those students striving for the metaphysical. During his years in Weimar, Itten used diverse avenues as he tried to explore in greater depth the question of the synaesthetic relationships between colours and sounds. Deviating from Kandinsky's assumption that the "optical-psychological experience" of colours is the same for all people,[26] Itten was convinced from very early on that there were different types of people when it came to colour perception. He firmly pursued this notion in his diary entries, by distinguishing different colour types among people, "the blue and yellow and red person" (see p. 72).[27] In the summer of 1918 these considerations on colour typology underwent a fundamentally new expansion in terms of worldview, when Itten studied the theosophical writings of Leadbeater and Besant.[28] The convictions that a person's individuality is accompanied by a colourful aura that can be expressed in a specific harmonious colour combination, a "sensory spectrum" of subjective colours, remained with Itten throughout his move to the Bauhaus in Weimar and later to the Itten School in Berlin. The extent to which he attempted as early as 1921 to relate his ideas of a person's colourful aura to the esoteric concepts of the Mazdaznan teachings on breathing and the body is also confirmed by his entries in the Tempelherrenhaus diary (see p. 72). He derived the systematic key to a four-part colour typology in line with the four seasons from astrological models. During classes in his Berlin school he tested such classifications empirically: Itten was convinced that viewers react differently to different configurations regarding colour harmonies and that they can be divided into four types, conforming to the seasons spring, summer, autumn and winter depending on their different colour-typological dispositions.

Itten developed his idea of a colour world differentiated into four basic types on a monumental scale in his picture cycle on the four seasons. Each of the four paintings depicts a specific harmonious colour segment of the colour circle. While the "youthfully bright, resplendent becoming of nature [...] is expressed through vibrant colours" in spring, with colours such as yellow, yellowy greens, light pink and light blue dominating the composition (24), autumn is characterised by faded colours, "dull brown and violet", orange and olive green (26).[29] 'During summer nature, elevated to the highest expression of form and colour, achieves its maximum concentration and three-dimensional, vital abundance of vigour. The warm, dense, active colours orange, red and blue lend themselves to being "the colourful expression of summer" (25). The palette for winter is defined by passive colours "that are contracting inwardly, cold and luminous with inner depth, transparent, spiritualising" – cold blue, blue-green, white and violet (27). Itten does not just explore this notion on the level of a serial abstract composition of different hues; he also applies it to seasonal landscape depictions in various degrees of abstraction. The insight that people evaluate colour impressions differently, depending on their psychological predisposition concerning colour, is a theory that he also introduced in his training programme for textile designers in Krefeld. He therefore incidentally gave crucial impetus to the metaphor of the four seasons as the foundation for the colour theory that is prevalent even today in advice on fashion and make-up.

During the 1930s Itten's confrontation with colour grew in significance and gained a new systematic quality in his notes on art theory, for example in the diary for 1930 that Itten wrote at his Berlin school. His colour theory emerged as a stand-alone project from 1940 onwards after his move to Zurich and was continued from then on in several stages throughout the 1950s with impressive rigour until the publication of *Kunst der Farbe* in 1961. It would seem that Itten's return to purely abstract paintings, such as the chequerboard and orthogonal colour-field compositions of the mid-1950s, was directly connected to his study of the elemental effects of colour. Every now and then individual pictures were created via a different avenue, namely artistic repetition, such as the second version of the painting *Horizontal–Vertical* (28).

24 *Spring*, 1963, Oil on canvas, 100 × 150 cm, The Würth Collection, Künzelsau

26 *Autumn*, 1963, Oil on canvas, 100 × 150 cm, The Würth Collection, Künzelsau

25 *Summer*, 1963, Oil on canvas, 100 × 150 cm, The Würth Collection, Künzelsau

27 *Winter*, 1963, Oil on canvas, 100 × 150 cm, The Würth Collection, Künzelsau

28 *Horizontal–Vertical*, 1963, Oil on canvas, 80 × 60 cm,
Private collection

29 *Festively*, 1966, Oil on canvas, 84 × 78 cm,
Private collection

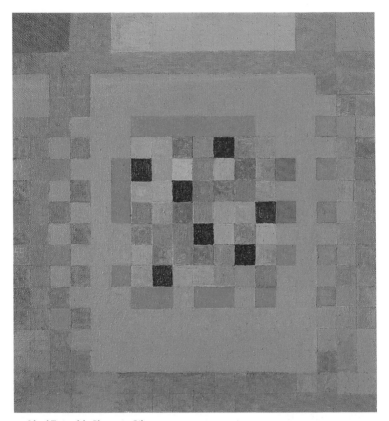

30 *Island Town of the Blest*, 1965, Oil on canvas, 75 × 71 cm,
The National Museum of Modern Art, Kyoto

Two fundamental aesthetic problems were of primary concern to Johannes
Itten: the analysis of the contrasting relationships of the colours and their
compositional synthesis to result in a comprehensive harmony.

Between these cornerstones of his colour theory, he explored how colour
works and how colour can be perceived in varying configurations, some-
times limiting the colours to just one, sometimes joyfully allowing in the
totality of all colours, such as in the painting *Festlich (Festively)* (29). He
therefore used different avenues to measure the various dimensions of his
colour cosmos. While individual works such as *Glückliche Inselstadt (Island
Town of the Blest)* (30) stand out because of their colour-contrast, featuring

vibrant blue, red and green hues, other works, such as *Adieu* (31), are built on brightness levels of that are delicately co-ordinated with each other. Then again in the painting *Concerto grosso* (32) Itten makes the colours shine as if they were window glass. However, the colour order is always designed as a polyphonically composed pictorial structure built on finely balanced considerations of equilibrium.

Using this notion of contrast and harmony as a guiding principle, Itten created pictures in his later years that do not serve as didactic illustrations of a "catechism of colour"; rather, they lead us along the trail of a complex methodological analysis of the visible and of perception itself. His fundamental insight that "the elements of a picture must be studied individually and consecutively, not together and not simultaneously, even if their reunification should create new problems" – thus the apposite characterisation by his student and assistant from his Berlin years, Boris Kleint – led Itten to an inexhaustible contemplation of the artistic possibilities of colour in his paintings: "Here, in the objective sphere, Itten does not

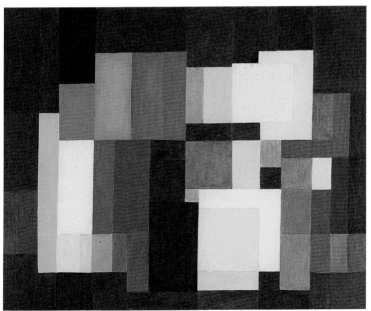

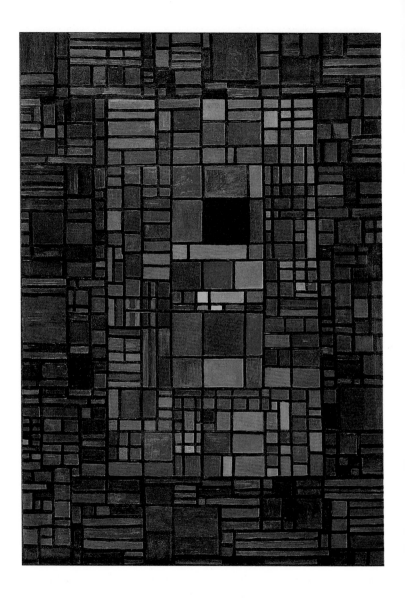

32 *Concerto grosso*, 1959, Oil on canvas, 140 × 100 cm,
Private collection

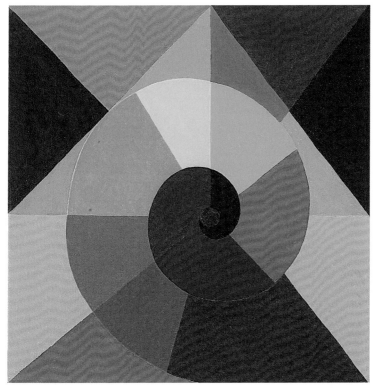

33 *Spiral*, 1967, Acrylic on canvas, 50 × 50 cm, Private collection

present us with an easy path but with many good ones: the map of what is possible in principle."[30]

Among the most important international successes in Johannes Itten's artistic reception – alongside the internationally noted publication of his *Kunst der Farbe* in 1961, a solo exhibition in New York in 1948, the exhibition of his œuvre in the Stedelijk Museum in Amsterdam in 1957, and the major retrospective in the Kunsthaus Zürich in 1964 – was his participation in the 33rd Venice Biennale in 1966. One year before his death, at the age of 78, he represented Switzerland, together with the sculptor Walter Linck, with a large-scale concentrated presentation of works in the Swiss pavilion. Itten displayed a selection of his largely abstract, geometrically composed early key works such as *The Encounter* (6) coupled with the

abstract late body of works after 1950, climaxing in the monumental four-part cycle *Four Seasons* from 1963 (24–27). The painter Johannes Itten, who was sometimes overshadowed when the art teacher Itten took the limelight, emerged on top again. With his wife Anneliese's help he prepared the presentation of his paintings with a comparison of his early key works from the pre-1920 avant-garde movements and his more constructive geometric abstractions after 1950. We can now take a new look at an artistic œuvre of more than 2,300 works that is both rich and in many aspects still unknown to the public.

The end of Itten's creative period is marked by a number of spiral compositions in which he calmly guides the colour gradations in free-floating dance-like movements, usually from the outside in towards the centre (33). A spiral composition drawn like this, which swirls outward around a red and a blue centre – like a freely unfolding musical clef – was left behind unfinished on his desk by Johannes Itten on the day of his death, 25 March 1967.

CHRISTOPH WAGNER *is Professor and Chair of Art History at the University of Regensburg. He taught at the universities of Saarbrücken and Bern, was a Visiting Professor at the Ecole pratique des Hautes Etudes (Sorbonne) in Paris, and held Visiting Scholar positions at the Universidad Nacional Autónoma de México and at the Institute of Advanced Study in Bern. At present, he is preparing the Catalogue Raisonné: Johannes Itten. Werkverzeichnis, Band I–III, Munich: Hirmer Verlag, 2018 ff. Johannes Itten. Catalogue Raisonné Vol. I–III, Munich: Hirmer Verlag, 2018 ff.*

1 Johannes Itten, "Jeder Mensch ist bildnerisch begabt", in: *Berliner Tageblatt*, 17 November 1928, 57th year, no. 545.

2 Johannes Itten, "Aus meinem Leben", in: Willy Rotzler, *Johannes Itten – Werke und Schriften*, Zürich 1978, p. 25.

3 Tagebuch I, p. 56 f., in: Eva Badura-Triska (ed.), *Johannes Itten. Tagebücher Stuttgart 1912–1916, Wien 1916–1919. Abbildung und Transkription* (vol. 1), *Kommentar* (vol. 2), Vienna 1990, vol. 1, p. 51 (between 4 January and 21 March 1915).

4 Tagebuch II, in: Badura-Triska 1990 (see footnote 3), vol. 1, p. 60.

5 Wassily Kandinsky, "Über die Formfrage", in: *Der Blaue Reiter*, Wassily Kandinsky and Franz Marc (eds.). Documentary new edition by Klaus Lankheit, Munich/Zurich 1984, pp. 132–182, here p. 173; English translation: "On the Problem of Form", trans. by Kenneth Lindsaych in: *Theories of Modern Art: A Source Book*, ed. by Herschel B. Chipp, Los Angeles 1968, pp. 155–158.

6 Diary entry from 1964, quoted from Rotzler 1978 (see footnote 2), p. 31, p. 395, footnote 15.

7 Rotzler 1978 (see footnote 2), p. 271.

8 Ibid.

9 Johannes Itten, Tagebuch XI (1918/1919), p. 24, in: Badura-Triska 1990 (see footnote 3), vol. 1, p. 402.

10 Letter to Anna Höllering, undated [2 June 1918], Itten estate, Zurich.

11 Cf. for example the publication by Erich Bischoff, *Im Reiche der Gnosis. Die mystischen Lehren des jüdischen und christlichen Gnostizismus, des Mandäismus und Manichäismus und ihr babylonisch-astraler Ursprung*, Leipzig 1906 (Itten estate, Zurich), which Itten heavily annotated.

12 Martin Buber, *Ekstatische Konfessionen*, Jena 1909 (Itten estate, Zurich).

13 Letter by Walter Gropius to Lily Hildebrandt, April 1920, Getty Center, Santa Monica (CA) (copy in the Bauhaus Archive, Berlin).

14 See the overview by Werner Brill, *Kollektiver Wahn. Eugenik und Antisemitismus. deutsche Paranoia mit Kontinuität*, unpag., http://www.wernerbrill.de/downloads/KollektiverWahn.pdf [accessed on: 4 July 2018] and the considerations by Ulrich Linse, "Mazdaznan – die Rassenreligion vom arischen Friedensreich", in: *Völkische Religion und Krisen der Moderne. Entwürfe "arteigener"'Glaubenssysteme seit der Jahrhundertwende*, Stefanie von Schnurbein and Justus H. Ulbricht (eds.), Würzburg 2001, pp. 268–291, and Ulrich Linse, 'Die Mazdaznan-Pädagogik des Bauhaus-Meisters Johannes Itten', available online: https://www.bauhaus.de/de/bauhaus-archiv/2129_publikationen/2132_bauhaus_vortraege/, accessed on: 11 June 2018, as well as Christoph Wagner, *Johannes Itten. Werkverzeichnis, Band I. Gemälde, Aquarelle, Zeichnungen. 1907–1938*, Munich 2018.

15 Johannes Itten, lecture typescript "MENSCHHEITSENTW.[ICKLUNG] KUNSTENTW.[ICKLUNG] MACHT DER KONZENTRATION", Munich 4.II.19, ink with pencil supplements, 28.2 × 21.5 cm, Itten estate, Zurich.

16 See Werner Brill (see footnote 13).

17 Paul Ortwin Rave (*Kunstdiktatur im Dritten Reich*, Uwe M. Schneede (ed.), Hamburg 1949 [Berlin 1987], pp. 80, 87) mentions nine works by Itten that were removed. The database of the confiscated inventory of "Degenerate Art" at the "Degenerate Art" Research Center at the FU Berlin initially listed 13, then 18 and now 33 works by Johannes Itten.

18 Johannes Itten, "Düsseldorf den 26.II.38.", Itten estate, Zurich.

19 Rotzler 1978 (see footnote 2), pp. 85–86.

20 Rotzler 1978 (see footnote 2), p. 404.

21 Letter in the Schlemmer Archive of the Staatsgalerie Stuttgart. Copy in the Itten estate, Zurich.

22 Cf. Rotzler 1978 (see footnote 2), p. 86.

23 Johannes Itten, *Tagebuch Weimar*, February 1920, p. 94, Johannes-Itten-Stiftung, Kunstmuseum Bern.

24 Johannes Itten, *Kunst der Farbe. Subjektives Erleben und objektives Erkennen als Weg zur Kunst*, Ravensburg 1961, p. 36.

25 Quoted after Wolfgang Venzmer, *Adolf Hölzel. Leben und Werk*, Stuttgart 1982, p. 113 f. undated.

26 Wassily Kandinsky, *Bauhaus-Vorlesungen*, 1932, original manuscript, p. 42. The Getty Research Institute for the History of Art and the Humanities, inv. no. 850910.

27 Sigriswil, September 1918, Tagebuch IX, p. 96, Badura-Triska 1990 (see footnote 3), vol. 1, p. 341.

28 Itten expressly mentions "Thought Forms" by C.W. Leadbeater and A. Besant and "Man Visible and Invisible" by C.W. Leadbeater', Tagebuch VII, p. 78, Badura-Triska 1990 (see footnote 3), vol. 1, p. 280.

29 All quotes from: Itten 1961 (see footnote 24), p. 131 f.

30 Both quotes from Boris Kleint, in: *Johannes Itten. Gesehen von Freunden und Schülern*, Ravensburg 1960, p. 25 f.

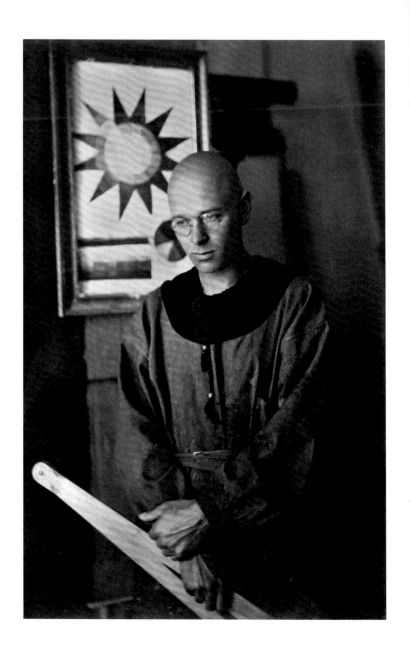

34 Johannes Itten in a painter's smock with golden ratio calipers and colour star, photographed by Paula Stockmar in 1921

BIOGRAPHY

Johannes Itten
1888–1967

1888 Johannes Itten is born in Süderen-Linden in the Bernese Oberland on 11 November. He is the eldest of four children of the teacher and farmer Johannes Itten and his wife Elisa Itten-Jost, a farmer's daughter from Emmental. Legal documents list 'Johann' as his first name and that is also the name his friends from Bern will use throughout his life.

1890–1898 Of his three younger siblings, his brother Gottfried dies in 1891, the year of his birth, while his brother Rudolf, who was born in 1890, dies in 1894 from whooping cough. In 1892, the year of his father's death, Itten's sister Maria Elisa ('Marie') is born. Johannes, who is four at the time, spends two years with his grandmother Elise Jost. His mother meanwhile marries the farmer Gottfried Fankhauser, who rejects the children from the first marriage. Although Itten returns to his mother in 1894, he spends the summer months working on the Marbachalp.

1898–1904 His father's brother, Jakob Itten, is appointed legal guardian in 1898. He is working as a notary and acting as the president of the citizens' council in Thun at the time. Itten spends his youth there, in his uncle's family on Schlossberg. He initially attends primary school and then the grammar school in Thun between 1899 and 1904. He makes first attempts at drawing and painting.

1904/05 In 1904 Itten attends to the boarding school of the Kantonal-Bernisches Lehrerseminar Hofwil (teaching seminar) near Bern, in order to complete his teacher training. This is the first time he receives instruction on how to draw and paint. He also attends his first music lessons, with Hans Wilhelm Klee, the father of Paul Klee, as his teacher. From 1905 Dr Ernst Schneider becomes director of the teachers' college, exposing the young teachers-to-be to the latest trends in educational reform, to 'free economy' ideas and to Sigmund Freud's theory of psychoanalysis.

1906–1908 Itten moves to Bern in order to complete the two-year senior classes of the teachers' college. We know of some initial early works from the year 1907: landscapes, portraits and a stage set. In late March 1908 he receives his graduation diploma from Hofwil college, and in early April his certificate confirming him as a primary school teacher. He obtains a job teaching at a primary school in Schwarzenburg in the canton of Bern.

1909 Itten quits his teaching job in late summer. He enrols on an art degree course at the École des Beaux-Arts in Geneva in time for the winter semester, but abandons it, disappointed, after just one semester.

1910/11 In the summer semester of 1910 Itten starts a four-semester maths and science course at the University of Bern as part of his training to become a secondary school teacher. In December 1911 he debuts as a painter with his oil painting *Vorfrühling an der Rhone* (Early Spring at the Rhone) in the Christmas exhibition of the Kunstmuseum Bern.

1912 After completing his studies at the University of Bern and obtaining his diploma certifying him as a secondary school teacher on 9 March, Itten goes on several trips with artist friends: he visits the Salon des Indépendants in Paris, the Kandinsky exhibition in the Galerie Goltz and the Alte Pinakothek in Munich, and other events including the Impressionist exhibition at the Kunsthalle in Mannheim and the Sonderbund exhibition in Cologne. He encounters the vegetarian diet ideas of the Mazdaznan doctrine for the first time. In October he resumes his art degree at the École des Beaux-Arts in Geneva.

1913 Itten quits his studies once again. He earns his living as a supply teacher. In July he sees paintings by Adolf Hölzel in the Galerie Thannhäuser in Munich. He decides to transfer to the art academy in Stuttgart, where Hölzel is teaching. After he is refused entry to Hölzel's master class he educates himself on the latter's artistic teachings by taking private lessons from Hölzel's student Ida Kerkovius. He starts recording his thoughts on art theory in his diary.

1914/15 Itten returns to Switzerland following the outbreak of the First World War on 28 July 1914. Adolf Hölzel's suggestion that he should move into one of the master-student studios in Stuttgart prompts him to return to Germany in November. Itten's painting reflects his friendship with the Finnish singer Helge Lindberg and the Viennese actress Hildegard Wendland. He produces his first completely geometrical, abstract paintings.

1916 Hildegard Wendland's suicide, which Itten witnesses at first hand, deeply unsettles him. In May he has his first major solo exhibition, featuring 24 paintings and 33 drawings, in Herwarth Walden's Galerie Der Sturm in Berlin. Itten meets Nell Walden, Georg Muche and Paul Klee. In September he participates in the exhibition *Hölzel und sein Kreis* in the Kunstverein Freiburg in the Breisgau region. He publishes his first writings on art theory, entitled *Fragmentarisches*, in the associated catalogue. At the suggestion of and with support from the socially well connected student Agathe Mark(-Kornfeld), Itten moves from Stuttgart to Vienna on 28 September, establishing a private art school in an attic flat in Peter-Jordan-Strasse 86/87 at the end of October.

1917 Itten meets many artists, architects, musicians and writers in Vienna's society and avant-garde circles. He focuses intensively on Indian and Far Eastern religious philosophy and on theosophy and mysticism, as well as on the Mazdaznan doctrine. Itten steps into the limelight in Vienna with his lecture *Über Kompositionslehre*. His private art school proves successful, allowing him to move to an attic studio in Nussdorfer Strasse 26–28 that summer.

1918 Emmy Anbelang turns to Itten after the death of Gustav Klimt, whom she had venerated. A passionate love affair culminating in marriage plans comes to an abrupt end when Emmy dies from the Spanish flu on 14 December. During a summer sojourn in Alma Gropius's house in Semmering, Itten meets Walter Gropius.

1919 In February Gropius appoints Johannes Itten as one of the first masters at his newly founded Bauhaus in Weimar. Itten exhibits his own works in his studio in Vienna and participates in the exhibition organised by the Viennese Freie Bewegung artist group. He publishes a portfolio with ten lithographs marking the end of his time in Vienna.
On 10 September Itten marries Hildegard Anbelang, the sister of his deceased fiancée Emmy. On 2 October he arrives in Weimar with his wife, where they move into a flat in Wilhelms-Allee 2 (now Leibnizallee 2). He establishes his studio in the 'Tempelherrenhaus' in Ilm-Park. During the masters' meeting on 5 October Itten is officially welcomed as a master at the Bauhaus. He starts teaching on 3 November and on 28 November he

35 Johannes Itten (front left) in the painting and drawing class, Geneva 1910

36 In the Stuttgart studio: Itten at the piano, Oskar Schlemmer in a deck chair in front of him, 1915/16

38 *Tower of Fire (Tower of Light),* 1919/20, lost

37 Johannes Itten, Vienna 1917

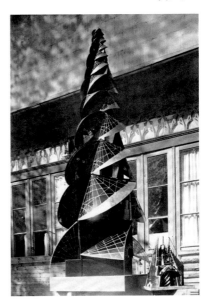

gives his opening lecture with the programmatic title *Unser Spiel / unser Fest / unsere Arbeit*. Fifteen of Itten's Viennese students have followed him to the Bauhaus in Weimar.

1920 Johannes Itten develops a mandatory preliminary course for all the students, the "Vorkurs" on the foundations of artistic design, which at the same time aims at fostering the students' creativity. In addition, as "Master of Form" he participates in the establishment of the workshops for glass painting, sculpture (stone), carpentry (1920–1922), weaving (1920/21) and metalworking (1920–1922). It is at his behest that important artists such as Paul Klee, Gertrud Grunow, Georg Muche and Oskar Schlemmer are invited to the Bauhaus. *Turm des Feuers* (Tower of Fire) becomes Itten's main work. His son Matthias is born on 12 June.

1921 *Kinderbild* (Children's Painting) is Itten's artistic tribute to his newborn son in 1921/22. It also symbolically romanticises elements of the Mazdaznan doctrine. He publishes his programmatic *Farbenkugel in 7 Lichtstufen und 12 Tönen* and the *Analysen alter Meister* in the almanac *Utopia: Dokumente der Wirklichkeit*, and is actively involved with editorial aspects of the project. With his two lithographs for the first Bauhaus portfolio, *Das Haus des weißen Mannes* (The House of the White Man) and *Gruss und Heil den Herzen...* (Salute and Hail to the Hearts) based on a text by Otoman Zar-Adusht Hanish, Itten demonstrates his commitment to the Mazdaznan doctrine. At the Bauhaus he increasingly dedicates his time to spreading these teachings, introducing Mazdaznan cuisine in the school canteen. Initial tensions between him and Walter Gropius arise.

1922 In contrast to Itten's holistic efforts at life reform aimed at nurturing the subjective and emotional creativity of the individual, Gropius pursues a re-orientation of the Bauhaus focused on the oneness of art and technology. In January Itten relinquishes his position as Master of Form in the workshops. He initially continues running the preparatory course, alternating with Georg Muche. On 21 September 1922 Hildegard Itten goes into early labour. Itten's second child dies in his presence, three days later. On 4 October he presents his letter of resignation to Gropius.

1923 Herwarth Walden stages a second solo exhibition featuring Itten's works in his Galerie Der Sturm in Berlin. On 18 March Itten gives his farewell lecture at the Bauhaus and leaves Weimar. From late March onwards he lives permanently in the international Mazdaznan temple community ('Aryana-Gesellschaft') in Herrliberg on Lake Zurich.

1924 Itten dedicates himself to the Mazdaznan doctrine. He gives lectures and establishes a Mazdaznan publishing company. Together with Gunta Stölzl he equips the Ontos workshops for hand-weaving and gives art classes. He does not draw and paint very much.

1925 Two of Itten's knotted carpets that he made in Herrliberg are awarded gold medals at the *Exposition Internationale des Arts Décoratifs et Industriels Modernes* in Paris. The Ontos workshops close down in April. Itten leaves Herrliberg on 1 October and moves to Berlin.

1926 Itten goes on lecture tours and spends the whole year teaching in different locations, but mainly in Berlin. On 1 September he moves his Berlin art school to Nollendorfplatz 1. In the summer he becomes involved in the exhibition *Ausstellung der Abstrakten. Große Berliner Kunstausstellung*. From 19 November Itten's works are displayed at the *International Exhibition of Modern Art* in New York. In autumn Itten embarks on the systematic recording of his ideas on art theory in his diaries.

1927/28 Itten gives lectures on modern art. In September classes begin at the Moderne Kunstschule Berlin. Johannes Itten – thus the name of his school, now located at Potsdamer Strasse 75. In February/March 1928 he hosts the exhibition *Photo, Malerei, Architektur* using his art school as the venue.

1929 In August he participates in the anniversary exhibition of the November Group at the *Juryfreie Kunstschau* in Berlin. On 1 December the Itten school moves to the new building in Konstanzer Strasse 14 in the Wilmersdorf district of Berlin.

1930/31 In March the Deutscher Werkbund publishes a special issue of the magazine *Die Form* featuring the Itten school. Towards the end of October Itten publishes his diary *Tagebuch. Beiträge zu einem Kontrapunkt der bildenden Kunst*. He invites Japanese teachers to come to his school to give courses in East Asian ink wash painting and ink brush techniques.

1932–1934 On 1 January 1932 Itten is appointed to run the newly founded *Preußische Fachschule für textile Flächenkunst* in Krefeld. He teaches textile designers, spending his time between Berlin and Krefeld. He is able to enlist the famous Japanese painter Yumeji Takehisa or courses in ink wash painting at his Berlin school from the end of 1932 to the start of 1933. He gives several Mazdaznan lectures in Berlin in 1933. The Jiyu Gakuen School in Tokyo puts on an exhibition about the Itten school. Anneliese Schlösser, who becomes Itten's second wife in 1939, attends the Fachschule für textile Flächenkunst in Krefeld from April 1933 to March 1935. On 1 April the Itten school in Berlin is closed as the result of Nazi pressure.

1935 Johannes Itten lives in Krefeld from early 1935. During an intense creative period he largely produces watercolours and drawings. From the summer semester 1935 to the winter semester 1937 Anneliese Schlösser works as a teacher in the showcase weaving mill of the Fachschule für textile Flächenkunst, at which around 90 students are now enrolled.

1936/37 As a result of pressure from the National Socialists there are growing difficulties and resistance in Krefeld. Nevertheless the Fachschule für textile Flächenkunst is prolific in its exhibition activities. In March/ April 1937 it is also involved in the Reichs-Textilausstellung in Berlin, which is visited by Hermann Göring among others. There are intense efforts to destroy the school at this time. Itten sends his plans for a textile academy to Göring in the hope of being able to move the textile school from Krefeld to Berlin. He imploringly sends the same plans to Walter Gropius on 14 November, coupled with the intention of implementing this school in the United States. A few months earlier, on 19 July 1937, the defamatory *Degenerate Art* exhibition opened in Munich, where Itten's works are also represented. Itten's works are removed from public collections in Germany. On 26 November the mayor of Krefeld dismisses him from the post of director of the Fachschule für textile Flächenkunst.

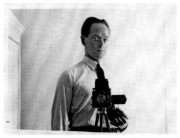

39 Johannes Itten photographing himself, Berlin 1928

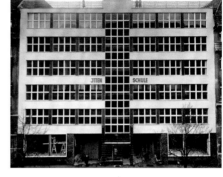

40 The Itten School at Konstanzer Strasse 14 in Berlin

41 The painter Yumeji Takehisa giving courses in ink painting at the Berlin school, 1932

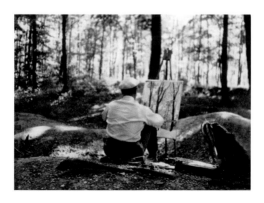

42 Itten painting *en plein air* in Krefeld, 1935

1938 On 26 February Ittem threatens the Reichskammer der Bildenden Künste with consequences by the Swiss embassy. His outraged reaction documents that he only gradually recognises the change to his position that is rapidly becoming more dangerous. As a result of Nazi pressure, orders are given for the closure of the Fachschule für textile Flächenkunst by 31 March. That same day Itten emigrates to Amsterdam, where he remains until the end of November. He wants to emigrate to the United States but then an opportunity opens up in Switzerland. On 18 March Johannes Itten and Hildegard Itten-Anbelang are officially divorced. On 29 April Willem Sandberg commissions Itten with the production of a large-format velum for the stairwell of the Stedelijk Museum in Amsterdam in time for the exhibition *100 Jahre Französische Kunst*. Itten applies for the position of director of the Kunstgewerbemuseum and the Kunstgewerbeschule in Zurich and starts to work for both institutions on 1 December, a position he will maintain until his retirement in 1953/54.

1939–1943 Johannes Itten and Anneliese Schlösser marry on 22 April 1939. In June 1941 their daughter Marion is born. In 1943 Itten also takes on the job of running the textile vocational college of the Seidenindustrie-gesellschaft in Zurich (until 1960), where his wife Anneliese also teaches.

1944–1947 His exhibition *Die Farbe in Natur, Kunst, Wissenschaft und Technik* in the Kunstgewerbemuseum in Zurich is the first time he presents his own teachings on colour in a systematic manner. In February 1944 his son Klaus in born, followed by his son Thomas in May 1946. From 1947 onwards he lives with his family in Zurich-Höngg and stays there until his death.

1948/49 Itten has his first solo exhibition in New York in 1948. In the following year Itten is charged with the establishment and running of the Rietberg Museum for non-European art.

1950/51 In 1950 he participates in the first Darmstadt Conversation about the idea of man in our time. In 1951 he is able to acquire several large Chinese sculptures for the museum from the Edward von der Heydt Collection in East Berlin.

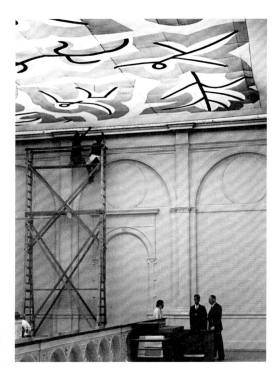

43 Johannes Itten, *Velum*, 1938, cloth appliqué, 18 × 9.5 m, Stedelijk-Museum Amsterdam, whereabouts unknown

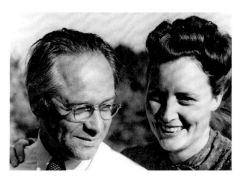

44 Anneliese and Johannes Itten, 1940

45 The many-armed, talking Shiva (Itten on his 60th birthday, 11 November 1948), photographic collage by Hans Finsler

1952–1957 The Rietberg Museum is opened on 24 May 1952. Itten will be its director until 1956. He implements many exhibitions in the Kunstgewerbemuseum and gives lectures and courses both in Switzerland and in other countries. He produces several publications on art theory and art education. In 1955 he moves into an artist's residence in Unterengstringen near Zurich and starts painting intensively again, creating a significant body of late works. A retrospective of his works is presented in the Stedelijk Museum in Amsterdam in 1957.

1958–1963 From 1958 onwards Itten is busy with the preparatory works for *Kunst der Farbe*, a book that is published in 1961. In 1963 Itten publishes his entire teachings on design and form in *Mein Vorkurs am Bauhaus*.

1964–1967 The Kunsthaus in Zurich puts on an Itten retrospective in 1964. In 1965 the Technische Hochschule Darmstadt awards him an honorary doctorate. In 1966 he receives the Dutch Sikkens Prize in Amsterdam. That same year Itten represents Switzerland at the 33rd Venice Biennale, together with the sculptor Walter Linck.

Johannes Itten dies in Zurich on 25 March 1967.

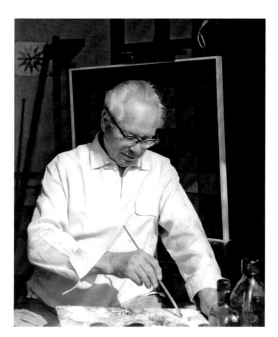

46 Johannes Itten
painting in his studio, 1965

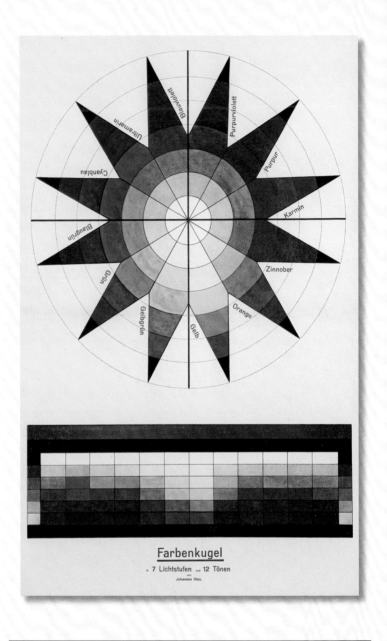

Colour Globe in 7 Light Stages and 12 Tones, 1921 (in: *Utopia. Dokumente der Wirklichkeit*, Weimar 1921), Lithograph, 32.4 × 24 cm

ARCHIVE

Discoveries, documents
1918–1931

I

By 1918 Itten had already developed his idea – following theosophical concepts – that people have different basic colours within them: he distinguished individuals based on different colour types, a "blue and yellow and red person":

The blue and red individuals recognise yellow as yellow; however, the triggering of the psychological reflex caused by the colour yellow will be different for these two different people. A yellow person will view a violet person as his/her antipole and vice versa; they will have a harmonious reaction, while red will be in disharmony with both yellow and violet.

It was from these considerations that Itten formed his new views on how abstract paintings should be designed, namely consisting of basic shapes and primary colours, such as in the works Horizontal – Vertical *from 1915 (p. 16) and* The Encounter *from 1916 (p. 17):*

Shapes and colours will be my symbols, my mythologies. The blue and yellow and red person, the yellow animal, the blue bird, the white fox, the light summer and the dark winter. [...] The entire picture from the motif of the basic elements, of which each one must appear consummate and pure once in the colour with which it harmonises.

Ia

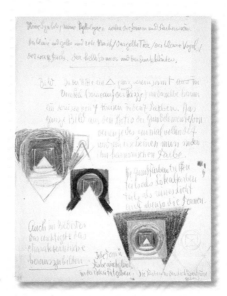

1b

In his sketch books, known as his "diaries", Itten covered hundreds of pages with his thoughts on art, art theory, the philosophy of art and the didactics of art. His reflections on his art, embedded within his worldview, are reflected in them in manifold ways. During his time at the Bauhaus in Weimar he created the famous Tempelherrenhaus-Tagebuch *(1a)*, which documents for example how intensively Itten grappled with theosophical writings, such as Claude Bragdon, A Primer of Higher Space (The Fourth Dimension), *New York 1913* and Annie Besant and C. W. Leadbeater, Thought Forms *(Leipzig 1908)*. Itten's sketches demonstrate how directly he reacted to concepts such as those of "magic squares" for the visualisation of multi-dimensional spaces or the colourful aura of man and then re-interpreted them artistically.

1a *Magic Square*, 1920, Indian ink and crayon, *Tempelherrenhaus-Tage-buch*, Weimar, p. 130 f., Johannes-Itten-Stiftung, Kunstmuseum Bern
1b *My Symbols, my Mythologies…*, Coloured and lead pencil, 28 × 21 cm, *Tagebuch IX*, Sigriswil, September 1918, p. 96, Johannes-Itten-Stiftung, Kunstmuseum Bern

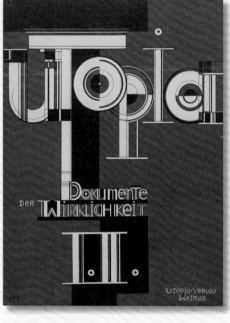

2a

2

The almanac Utopia, *published in 1921 with Bruno Adler as editor, was the first time that Itten had presented a comprehensive programmatic manuscript at the Bauhaus: featuring text excerpts from the philosophical writings of Plotinus, Marsilio Ficino, Nicholas of Cusa and Paracelsus, and supplemented by the hymn of creation from the ancient Indian Rigveda as well as by ancient Egyptian, Tibetan and Chinese texts. He aimed to invoke a list of highlights of significant ideas in history that went beyond any one period in history or culture in order to generate a new intellectual, artistic beginning for humankind after the total catastrophe of World War I. In the history of ideas there are*

2a Almanac *Utopia. Dokumente der Wirklichkeit*, Weimar 1921
2b *Before me is a Thistle …*, 1921 (from the almanac *Utopia*), Lithograph, 33 × 24 cm

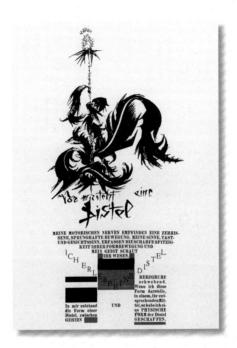

MEINE MOTORISCHEN NERVEN EMPFINDEN EINE ZERRIS-
SENE, SPRUNGHAFTE BEWEGUNG. MEINE SINNE, TAST-
UND GESICHTSSINN, ERFASSEN DIE SCHARFE SPITZIG-
KEIT IHRER FORMBEWEGUNG UND
MEIN GEIST SCHAUT
IHR WESEN.

2b

further key pictures Itten considered significant, such as a depiction of Christ
from the Bible moralisée, a depiction of John the Baptist in the Desert by
Hieronymus Bosch, Master Francke's Nativity of Christ from the St Thomas
altarpiece and photographs of the Indian Hutheesing Temple in Ahmedabad,
as well as of the late-Gothic spire of Freiburg Minster. In the "Analysen Alter
Meister", which Itten decorated artistically with calligraphy for the Utopia
almanac, he wanted to point towards a new understanding of the timeless
principles of these works of human artistic and intellectual history. At the same
time Itten demanded that artistic depictions should not just imitate the shapes
of things; instead, internalised empathy should be used to "experience" the
formal language of a thistle, which should then be made comprehensible to
viewers (2b):

There is a thistle in front of me. My motor nerves sense a jagged, erratic
movement. My senses, my sense of touch and sight take in the painful
pointiness of the movement of its form and my spirit sees its nature. I
experience a thistle.

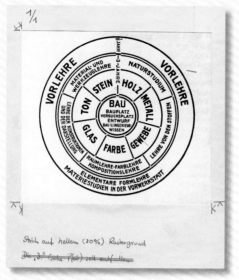

3

3

With his "Vorkurs" – "preparatory course" – Johannes Itten developed one of the most innovative and current educational formats for artistic education, one which is still used internationally at art academies today. Accompanied by a free process of intensive and artistic self-discovery, the students spent their first semester experimenting with materials ("material studies") and the principles of design ("elementary theory of forms"). It was only after the successful completion of this "preparatory course" that the students were able to enter the various workshops or take further courses on "materials and tools" or "colour and composition". After completing this training the students then participated in actual construction tasks, supported by "construction and engineering theory". Looking back, Itten wrote the following in 1963 about the preparatory course he oversaw until 1923:

3 Scheme for the structure of teaching at the Bauhaus by Walter Gropius, with the preliminary course (*Vorkurs*) introduced by Johannes Itten (here from Itten's manuscript, *Mein Vorkurs*)

4 Dedication for the Japanese artist Tomioka Tessai, *Berliner Tagebuch*, vol. III, p. 299, 1930/1931

At the start of my lessons in the mornings I used relaxation, breathing and concentration exercises to create the mental and physical readiness in the class that made intensive work possible. Training the body as an instrument of the mind is of great significance for the creative person.

4

Itten was greatly interested in Japanese ink painting from the 1930s. He believed that calligraphy was the epitome of all artistic activity implemented with a relaxed hand. He dedicated a tribute (4) to one of the great masters of Japanese calligraphy, Tomioka Tessai (Tomioka Yusuke/Tomioka Hyakuren; 1837–1924), in his Berliner Tagebuch. *And from the Japanese side there was interest in Itten's works and writings on art theory from early on, after the Itten school in Berlin had already been featured in an exhibition by the Jiyu Gakuen school in Tokyo in 1933 and many of Itten's texts were later translated into Japanese.*

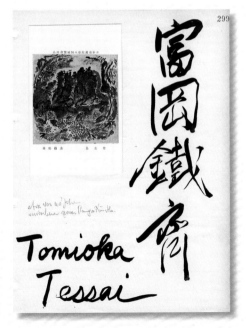

4

SOURCES

—
PHOTO CREDITS

The artworks were kindly made available by the Kunstmuseum Bern: 16; Kunstmuseum Bern, Gottfried Keller-Stiftung: 20; Kunstmuseum Bern, Johannes-Itten-Stiftung: 13, 39, 72–75, 77; Archiv Christoph Wagner: 19, 42–43; Kunstmuseum Stuttgart: 15; Itten-Nachlass Zurich: 8, 10, 14, 23, 25, 26, 29–37, 41, 46–53, 70; Kunsthaus Zurich: 17, 24; Itten estate in the Zentralbibliothek Zurich: 54–69, 76.

—
THE FOLLOWING SOURCES ARE QUOTED IN THE ARCHIVE:

Johannes Itten, *Tagebuch VII*, 29 April 1918, p. 57 f., Johannes-Itten-Stiftung, Kunstmuseum Bern: 72

Johannes Itten, *Tagebuch IX*, Sigriswil, 7 September 1918, p. 96, Johannes-Itten-Stiftung, Kunstmuseum Bern: 72 f.

Johannes Itten, *Vor mir steht eine Distel ...*, from: 'Analysen alter Meister', in: *Utopia. Dokumente der Wirklichkeit*, Bruno Adler (ed.), Weimar 1921, pp. 43: 75

Johannes Itten, *Mein Vorkurs am Bauhaus*, Ravensburg 1963, pp. 12: 77

Published by
Hirmer Verlag GmbH
Bayerstrasse 57–59
80335 Munich
Germany

Cover illustration: *Country Festival* (detail),
1917, see page 10
Double page 2/3: *Ribbons (Movements)* (detail),
1918, see page 23
Double page 4/5: *Spring* (detail), 1963,
see page 46

The present volume contains, with kind
permission, a number of text passages from the
publication *Johannes Itten. Catalogue Raisonné,
Vol.: I. Paintings, Watercolors, Drawings.
1907–1938*, Munich: Hirmer Verlag (2018).

www.hirmerpublishers.com

TRANSLATION
Michael Scuffil, Leverkusen
Josephine Cordero Sapien, Exeter

COPY-EDITING/PROOFREADING
Jane Michael, Munich

PROJECT MANAGEMENT
Gabriele Ebbecke, Munich

DESIGN/TYPESETTING
Marion Blomeyer, Rainald Schwarz, Munich

PRE-PRESS/REPRO
Reproline mediateam GmbH, Munich

PAPER
LuxoArt samt new

PRINTING/BINDING
Passavia Druckservice GmbH & Co. KG, Passau

Bibliographic information published by the
Deutsche Nationalbibliothek
The Deutsche Nationalbibliothek lists this
publication in the Deutsche Nationalbibliografie;
detailed bibliographic data are available on the
Internet at http://dnb.dnb.de.

ISBN 978-3-7774-3172-7

Printed in Germany

●
————————————

THE GREAT MASTERS OF ART SERIES

ALREADY PUBLISHED

www.hirmerpublishers.com